WILLY
RONIS **55**

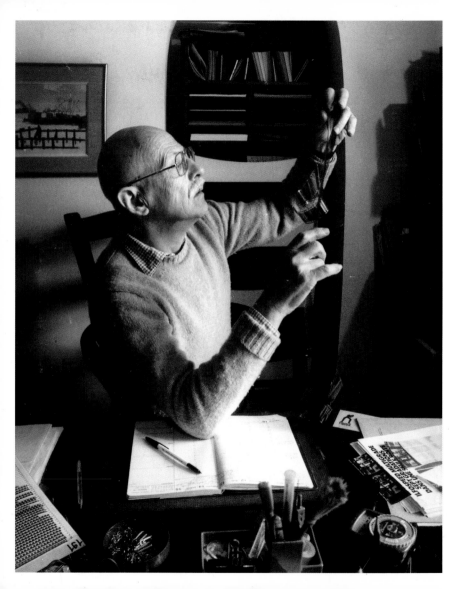

2.3

In his 1968 essay 'Understanding a Photograph', John Berger drew the following conclusion: 'We think of photographs as works of art, as evidence of a particular truth, as likenesses, as news items. Every photograph is in fact a means of testing, confirming and constructing a total view of reality. Hence the crucial role of photography in ideological struggle. Hence the necessity of our understanding a weapon which we can use and can be used against us.' There is an affinity here with Willy Ronis's words of 1951: 'Photography is a language ... [the photographer] responds to the outer world in the light of his own subjective leanings before he snaps the shutter ... there can no longer be any question of art, if one accepts the usual sense of the term, since the personal intervention by the photographer is reduced almost uniquely to the selection of the crucial instant.'

Ronis, then, has done his fair share of 'testing, confirming and constructing'; and, in an age that has abandoned ideology because it is embarrassed by faith and inconvenienced by principle, he still knows the meaning and value of struggle. He knows that doubt is an essential corollary of faith (faith in humanity, not in God), and that principles, if they are to be worth anything, demand sacrifices. This knowledge is a part of him; one of his gifts is to identify it in others.

Ronis lives in an undistinguished building in an undistinguished street in an undistinguished part of Paris. It is no coincidence that this description can stand for the locations in most of his Paris photographs. We had not seen each other for some years when I followed his precise instructions ('board the last carriage on the Métro') to reach his apartment in the east of the city. He lives, secure behind a coded entrance, eight floors up. From the generously proportioned window of his apartment, his 'belvedere' as he calls it, I see the

pleasing mixture of old and new architecture that testifies to the city's continuity. This is very important for a man who has little time for nostalgia, who lives his life in the present tense.

Let me say again that we had not seen each other for some years. I remind myself of this because Ronis has now entered his tenth decade, while I am merely nudging the border of my sixth. I had expected him to be noticeably more frail but, in truth, he seems as fit as I've ever seen him, and far fitter than many a much younger man. He remarks — but does not complain — about the weakness of his legs. But he walks unaided by stick or cane and, I suspect, walks all the more to defy infirmity. He confesses that, two years ago, he had to abandon one of his passions: parachute-jumping. Again, I feel that this has less to do with age than with frustration. He knows that he would never be allowed to jump alone, but always in tandem with an instructor. Perhaps he is annoyed with himself for only taking up the sport when he was eighty-four. His mind, though, is as agile as it ever was. As we look at this selection of fifty-five images, he plunges anew into each moment, every location. At the end of it, I am, in all my tender youth, exhausted. He is still fresh, and invites me to stay for dinner.

In the kitchen, a confession: 'I don't cook, I only heat things up.' This point is reinforced when I notice that, on the outside terrace, Ronis has deliberately set my place, not his, at the side of the table nearer the kitchen door. In the kitchen, he is brisk. The food is from packets and placed in a microwave. 'I never learned to cook, and it's too late to start now. I never learned because I didn't get on with my mother, and so I stayed out of the kitchen as a child.' This last remark, from so discreet and courteous a man, is unusually intimate. But it throws us back for a moment to where we should properly start: at the beginning.

Here then is an image unrecorded by a camera. Ronis's mother is seated at the piano, giving a lesson. Her son, three years old, takes a series of jumps across the room, one jump for each note. It takes him seven jumps to reach the double-doors of the dining room – doh, ray, mi, fa, soh, la, ti – then he slaps his hands on the doors – doh – to mark the end of each octave. This is the way in which he learns the musical scales; it is the way, too, that he absorbs music into his every action.

Ronis was born in 1910. His parents were Jewish immigrants who had arrived in France from eastern Europe in the first years of the twentieth century. Emmanuel Ronis, Willy's father, had fled the pogroms of his native Odessa; his mother was Lithuanian, and had spent much of her childhood in Germany. Emmanuel and his wife set up home together just south of Montmartre. Their social lives revolved around the local synagogue and the warm, largely artisan, community in their apartment block in the Cité Condorcet.

Like his wife, Emmanuel Ronis was musical, but he earned his living from his modest photographic business. He modified the family name to 'Roness', partly to help the native French pronounce it, partly no doubt to mask its foreign origins. There were three main components to the business: portraiture, retail, and retouching of prints for other photographers. It was demanding work. Emmanuel started work early, rarely got home in time for dinner, and took no more than ten days' holiday each year. His wife, by contrast, took two months' holiday every summer. Their marriage was not a happy one. Willy, who proved himself a gifted draughtsman at school, was often called upon to turn his hand to retouching portraits. He augmented his drawing skills with frequent trips to the Louvre, where he first discovered that master of everyday life, Bruegel.

Ronis was a frail child — born with a hernia that remained uncorrected until he was eleven. He was also rather solitary, due in part to his profound shyness and the fact that he was an only child until the birth of his brother Georges in 1918. But he was also wilful and could, at the age of seven, refuse to kneel before a schoolteacher because 'in my religion, we do not kneel'. He was conscious of the unhappiness in his parents' marriage, and especially of the pressure his mother put upon his father to maintain the petit-bourgeois status she found so important. With the cruel honesty that only children can muster, he took sides. He gave all his love to his 'angelic' father. As for his ever-present mother ... he stayed out of the kitchen.

Contained in those four preceding paragraphs are elements that would have a direct effect on Ronis's formation as a photographer: a sense of solitude, nourished by being Jewish (France has a long and shameful history of anti-Semitism), that places one on the side of the dispossessed; an awareness of community, and the knowledge that one can belong; a sensitivity to the composed image, especially where it concerns the properties of light and the everyday human presence; an early acquaintance with photographic technique, taught by a beloved father. Above all, there is the wilfulness that fed into his later independence; the cold relationship with his mother that launched him on a search for love and friendship; and, of course, the constant presence of music that enriched his life and, twinned with a demanding visual aesthetic, gave his work its sense of order.

Ronis planned to be a composer. His parents had other ideas, urging him to study law and get a sensible job. He did study law, for a year at the Sorbonne, but he kept up his musical studies and paid for them by playing the violin in a

restaurant orchestra. In the end, fate dealt a cruel hand. Emmanuel Ronis developed cancer, and his prolonged illness meant that Willy had to take a more active part in the family business. Quite apart from the anguish caused by his father's condition, it must have been painful for him to give up his hopes of a career in music.

Two things provided compensation. The first was his discovery of the ways in which photography was being used by a new generation of photographers, largely from eastern Europe, who brought a new vision to the medium and freed it from its too obvious painterly influences. Artists such as the Hungarian László Moholy-Nagy and the Russian Constructivist Alexander Rodchenko were showing the world new ways of looking at and using photography. The Surrealists, too, had a profound impact. Not merely in their visual aesthetic, but in such texts as Louis Aragon's *Le Paysan de Paris* (*Paris Peasant*, 1926). As Jean-Pierre Montier (in his study of Cartier-Bresson) observed, 'they conferred respectability on the aesthetic of the encounter, the banal, the unexpected. In the twentieth century, it was the street that acquired the aura of a poetic world, just as ruins had for the Age of Enlightenment and the lake shore had for the Romantics.' In 1927 André Kertész, another Hungarian, held his first exhibition in Paris, and it was soon clear that photography had an artistic validity all its own. There was to be another, harsher, compensation.

Ronis came to feel that he was temperamentally unsuited to the musician's life; that he would have been a mediocre composer. When André Malraux was French Minister of Culture, he was asked, 'If André Malraux were a painter, which type would he be?' Without hesitation, Malraux replied, 'Failed'. Ronis has the same clear-eyed view of his lost musical potential. It has never dimmed his love of

music, but it has freed him to concentrate his talent for photographic composition, which, with its dependence on time, is far closer to music than to painting.

If painting is occasionally evoked in Ronis's photographs, it is only because painting and photography have the same point of departure: looking. His most celebrated photograph, *Le Nu provençal* (*The Provençal Nude*) (page 51), may recall Pierre Bonnard's paintings of his wife Marthe, but the connection goes beyond the obvious subject matter and setting. In its unforced domesticity and its real intimacy, the image is a reminder of those breathtaking moments when a negligent glance at a lover can fill our hearts. As it was with Bonnard, whose paintings of Marthe always showed her in youth, so it is with Ronis's photograph of his wife Marie-Anne, which holds her in time, keeps her forever young. That is the true connection with Bonnard: the act of memory, and of love.

The lessons he learned from Bruegel certainly helped Ronis with his many photographs of crowds. Looking for a moment at that teeming Algerian street in 1969 (page 83), you see fifty or sixty clearly discernible faces and figures. But the chances are that you will remember only one of them: the young girl in a short dress with that penumbra of light in her hair. True, she is aware of the photographer; but she is not the only one. True, she is fairly low and centrally placed in the frame. But these are not the reasons why she stays so firmly in the memory. At the bottom of the frame are two men, one on the left and one on the right, facing each other. Their centres of gravity form a natural, invisible triangle with that of the girl. They balance her or, if you like, act as a kind of counterpoint. Try masking them out of the frame. The girl is still central but the eye wanders, the composition falls apart. The music of time improvises all the way. Ronis follows that improvisation and, in a style that draws on aspects of

Bruegel and Bach, renders its harmonies visible. Like so many of those in the Jewish Diaspora who chose the violin because of its portability and then astonished us with their skill, Ronis has carried his camera to virtuosic heights.

At his father's shop, Ronis met other photographers of his generation who had similar ideas to his own. Among these was a Polish Jew called David Szymin, later to be known as David Seymour, and more familiarly as Chim. Willy became good friends with Chim and later in the 1930s came to meet and befriend both the Hungarian Jew André Friedmann, who had become famous under his pseudonym, Robert Capa, and the French photographer Henri Cartier-Bresson. These three of Ronis's friends would go on, with the Englishman George Rodger, to found the celebrated Magnum agency. But, back in the 1930s, they were still establishing themselves as photojournalists, supplying images to such illustrated magazines as Lucien Vogel's *Vu*, which would have a profound influence on later photo-magazines like *Life* in the United States and *Picture Post* in Britain. Ronis would soon be one of their number.

In 1936, the year of the rise of the Popular Front in France and the start of the Civil War in Spain, Ronis's father died. His business, which had never recovered from the devastating ripple-effect of the 1929 crash, was declared bankrupt and forcibly sold off. Salvaging a few items for himself, Ronis decided to make his living as a freelance. As his family's principal breadwinner, he could not follow Chim and Capa to Spain. But his political sympathies had been formed, placing him firmly on the left and closely allied to the French Communist Party.

Ronis took two pictures during the years of the French Popular Front that vividly convey the feeling of the times. These images are but fragments of lived

experience, but we cannot stand apart from them. They offer no answers; they force us to question. Look at the Popular Front supporters on the Rue Saint-Antoine in 1936 (page 21). Their coiled fervour reflects the seriousness of their hope: that the newly elected government will serve a working class whose needs had been bypassed for more than a century. By 1938 the left was back in opposition and the hard-won reforms were being swiftly dismantled. The image of the strike meeting at the Citroën factory (with only female workers present) captures the urgency of the situation (page 23). Each of these photographs is, in itself, powerful. Each demands that you seek out the context. It need hardly be added that each image honours its subject.

Honouring the subject: another source of discomfort in our 'ironic' age where so many images, in books or on gallery walls, invite us to mock and pity the tastes and the lives of our contemporaries. This, of course, is not irony but low wit, and its time will pass. Ronis honours the easily mocked, the easily pitied, by refusing to photograph them. Choosing when not to take a photograph is a mark of integrity, but a hard one to illustrate. The human urge to compromise is so powerful that integrity is usually the first thing we abandon, the last thing we reclaim. But, for Ronis, it has been a constant, a leitmotif. He had wanted to be a musician; fate chose another path for him. He avenged himself on fate by creating a wealth of images that are as musical as any sounds you'll ever hear.

Although he was receiving commissions for the industrial and commercial photography that had been a key part of the family business, Ronis also continued to take photographs in his own time. Apart from his work in the streets of Paris, he concentrated on the pastimes that interested him. With an

athleticism that made up for his years of childhood frailty, he had become an accomplished skier, and he soon achieved a reputation for his images of winter sports. He sold these to the specialist sports magazines such as *Sports en Vacances*, and combined this with his reportage and freelance work for a number of left-wing magazines such as *Regards*, *Ce Soir* and *La Vie Ouvrière*. Ronis's photographs were just beginning to bring him a reputation when the outbreak of war brought his career to an abrupt halt.

He was called up and served as an airfield guard and a quartermaster until the fall of France. On his demobilization, he found occupied Paris an increasingly dangerous place for a Jew. In June 1941 he set out with a group of friends to cross into unoccupied territory. They ran into a German patrol and Ronis only just managed to escape into nearby woods with the Germans firing shots after him. His friends were all caught. Ronis made his way to the south of France where he met up with the poet and screenwriter Jacques Prévert, who knew and admired his work. Prévert found Ronis a job with a touring theatre company. Later, he managed to find employment with established photographers including Emile Savitry and Sam Levin. Working in Levin's darkroom must have seemed like a retrograde step for Ronis, who moved on to work with a woman he met at his brother's wedding in Cannes. This was Marie-Anne Lanciaux, who was making a living from painting jewellery and invited Ronis to help her. Marie-Anne's husband was in hiding from the Nazis, and she was left to care for their young son Vincent. After the liberation of Paris, Ronis was able to return to the capital and resume his freelance career. He met Marie-Anne again and learned that her husband had survived, but had decided not to return to her. Soon afterwards, he married Marie-Anne and took great joy in becoming a father to Vincent.

The immediate post-war years brought Ronis a number of commissions for social documentary subjects. In common with many progressive artists, he and Marie-Anne became members of the Communist Party, and his photographs and her paintings during this period reflected their commitment to and sympathy with the difficulties of post-war working-class life. In 1946, Ronis joined the Rapho Agency (founded in the 1930s by the Hungarian Charles Rado, who escaped to America during the war), which had been re-established by Raymond Grosset.

Although there were many magazine outlets for photographers in Europe, the payment was often poor and film stock was rationed. By contrast, the American magazine *Life* offered higher rates and a valuable source of high-quality film. Ronis received many assignments from across the Atlantic. But the growing Cold War climate in America led *Life* to caption his images in ways that he could not tolerate. Ronis insisted that he should be allowed to write his own captions. His principled stand cost him dear: *Life* removed him from their list. In 1955, when he found that photographs supplied to American publications by the Rapho Agency were being used to encourage 'red-baiting', he broke with Rapho itself (though he attached no blame whatever to Grosset and his colleagues, and rejoined the agency in 1972).

By the late 1950s, Ronis had made an international reputation for himself. His work had been widely published and had been featured in exhibitions at home and abroad. Two exhibitions curated by the American Edward Steichen were of great importance: the first of these was 'Five French Photographers' at New York's Museum of Modern Art in 1953, where Ronis's work was shown alongside that of Cartier-Bresson, Izis, Brassaï and Robert Doisneau. Shortly

afterwards, his shot of Vincent with his model plane featured in Steichen's renowned exhibition 'The Family of Man'. In 1954 he published his celebrated book *Belleville-Ménilmontant*. This entirely personal project documented everyday life among the working-class and often immigrant population in the twin *quartiers* of Paris's twentieth arrondissement. His status was further acknowledged at the 1957 Venice Biennale, where he was awarded the Gold Medal.

But the 1960s saw a new generation of photographers taking an increasingly prominent role in the print media. A grittier aesthetic began to make its presence felt, allied to the rise of a group of inventive fashion photographers who turned their backs on the aloof glamour of the past and took to the streets. This was the era of the Beatles and of Vietnam. The events in Paris of May 1968 became emblematic of an era dominated by the demands of rebellious youth. Only a handful of photographers had documented the 1944 liberation; in 1968 the streets were swarming with hundreds of photojournalists. Like many of his generation, Ronis found that his own aesthetic was considered old-fashioned, too gentle for this brave new world. He turned to teaching to earn his living. In 1972 he moved the family to Provence, first to Gordes where he and Marie-Anne had had a house since the late 1940s, and later to L'Isle-sur-la-Sorgue. For eight years he taught at Avignon, Aix-en-Provence and Marseilles.

In 1975 Ronis succeeded Brassaï as president of the National Association of Photographers-Reporters-Illustrators, and a wind of change began to blow through French cultural life. His work was rediscovered by a new generation. In 1980 exhibitions of his photography were held in Athens and New York, and a

retrospective book of his pictures *Sur le fil du hasard* (*On Chance's Edge*) was published in Paris. Most significantly, the French state invited him to donate his archive of 95,000 negatives to join the collections of such photographers as Jacques-Henri Lartigue and Kertész to be preserved for posterity. In exchange, the state enabled him to buy an apartment in Paris, and he was able to return to his native city. But the joys of this late renaissance were clouded by terrible losses: with a bitter irony that needs no comment, Vincent died in a hang-gliding accident in 1988; while Marie-Anne, whose memory Ronis had so luminously fixed one Provençal afternoon, succumbed to the bleak twilight of Alzheimer's disease. She died in 1991.

In the past few years Ronis has been garlanded with honours: he has the Légion d'Honneur, is a Commandeur de l'Ordre des Arts et des Lettres, and has most recently been named a Commandeur of France's National Order of Merit. In Britain, a retrospective of his work was shown at Oxford's Museum of Modern Art in 1995. The following year, the Pavillon des Arts in Paris hosted a major retrospective featuring over 270 images and subtitled 'Seventy Years of Clicks'. At that point, Ronis decided to retire from the social documentary photography that was at the heart of his work. 'I looked around the Pavillon and thought "that's enough",' he tells me, 'although I have other projects – lectures, books and exhibitions – to keep me busy; and I still photograph nudes. Also, I am no longer as agile as I once was. If you see an interesting subject across the street and you can't run to capture it, it becomes too frustrating after a while.'

France now has privacy laws that require photographers to obtain permission from their subjects before they can photograph them. This makes it all but impossible for the continuation of the kind of street photography that Paris

once nurtured and developed, and at which Ronis excelled. Inevitably, it lends his images a nostalgic quality that does them less than full justice. For what lies at the core of his work is not nostalgia but memory — a weapon against loss, and an armoury for the future.

As communities are increasingly atomized, memory has an urgent value. John Berger summed up the photographer's motivation in its simplest form: 'I have decided that seeing this is worth recording.' Today, when so much that is worth recording may be lost to us, Ronis's photographs bear witness to the accidental poetry of everyday living. They testify to our common significance and our shared heritage. They are not glimpses of a foreign past; they are truthful images of ourselves.

**Cornil, la Corrèze, 1928.** Ronis spent many holidays in this part of central France during his adolescence. 'My father had given me a camera two years beforehand, and I was unaware that I would become a professional photographer. The landlord of our boarding house owned a sawmill, of which there were many in this very wooded area. He is posed here between his son-in-law and one of his workers.' This uncropped photograph, printed from the whole negative, shows how early in life Ronis developed his compositional eye.

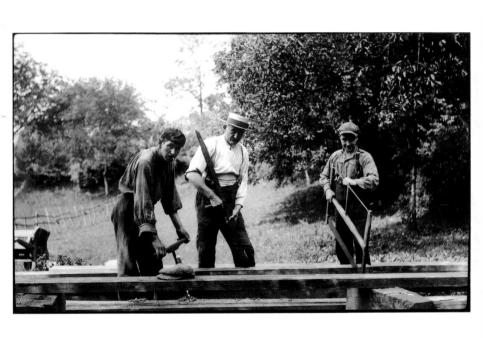

**Night in the Chalet, Vosges, 1935.** Ronis was one of a dozen young skiers, male and female, on holiday in eastern France. This shot was taken shortly after the evening meal when everyone returned to the slopes except this young woman who preferred to relax. 'This was not set up, the image offered itself to me. I screwed my camera to a pole and exposed the film for half a second, using only the light from the oil-lamp on the table.'

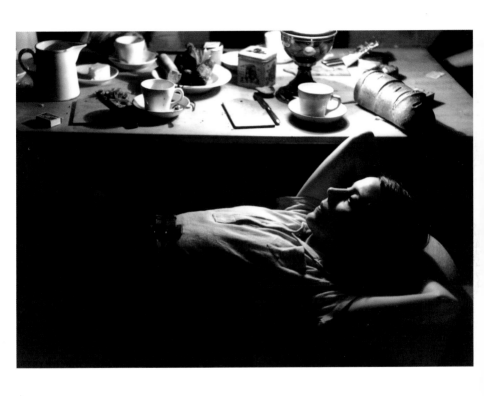

**Rue Saint-Antoine, Paris, 14 July 1936.** The traditional Bastille Day celebrations took on a special significance in 1936 with the rise to (short-lived) power of the left-wing Popular Front. The occasion marked Ronis's first assignment as a freelance photojournalist and, while he photographed the newly elected politicians in the parade, it is this image of the watching crowd that has truly endured. More than sixty years after sitting so proudly on her father's shoulders, the little girl in the picture lunched with Ronis near to the scene of the original photograph.

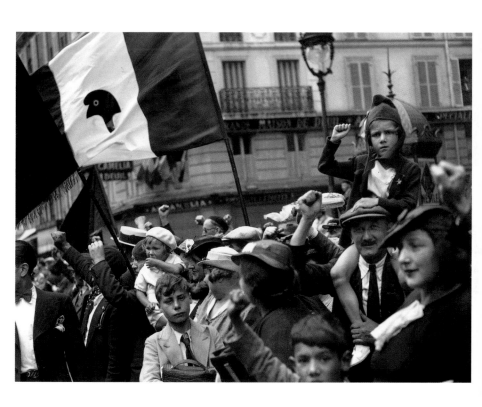

**Strike Meeting, Citroën-Javel, Paris, 1938.** This charged image of union dele-
gate Rose Zehner addressing her comrades in the car factory's canteen went
unseen for more than forty years. Ronis, covering the strike for the weekly
magazine *Regards*, had already visited the occupied workshops when he came
upon this hastily called meeting. 'The atmosphere was tense; I took one shot and
left.' The image was badly under-exposed and, lacking sufficiently high-contrast
paper, Ronis left it unprinted until he rediscovered it for his book *Sur le fil du
hasard* (*On Chance's Edge*) in 1980.

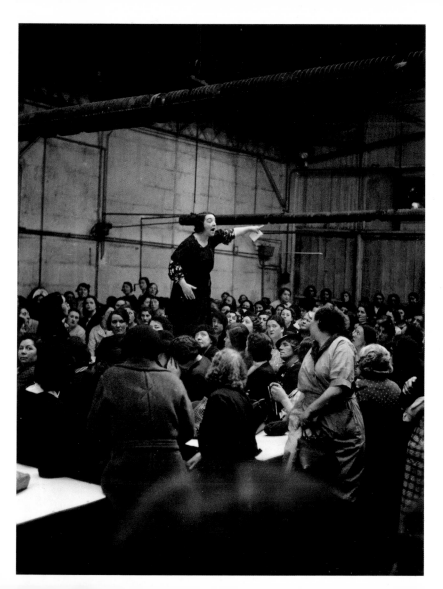

**The Elevated Métro, Paris, 1939.** This is an excellent example of Ronis's speed of response when nature provides the kind of 'key light' so often created by cinematographers. 'The photo was taken one morning on the elevated section of the Métro in the east of Paris as the train passed a gap in the surrounding buildings allowing a strong light to illuminate the pale face of this young woman.'

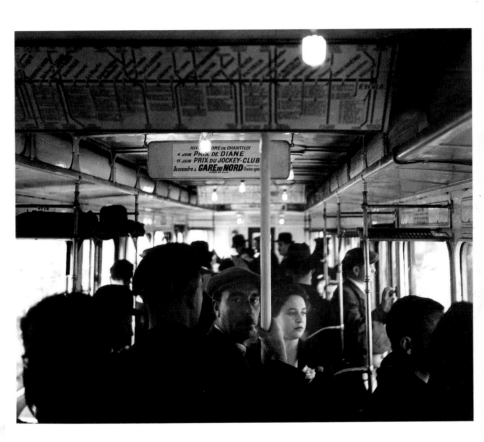

**The Prisoner's Return, Paris, 1945.** This touching image, with its faint echo of John Everett Millais's *The Order of Release* (1853), comes from a reportage commissioned by the French national railway company SNCF, which transported liberated prisoners-of-war from the Franco-German border into Paris. Here a young nurse bids farewell to an injured soldier who, along with many others, had been in her care during the long journey home. Aware that the nurse and the soldier might each have a spouse or sweetheart, and having no wish to cause them any embarrassment, Ronis decided against publishing this image at the time. He was finally persuaded to release it for publication in 1980 for *Sur le fil du hasard*.

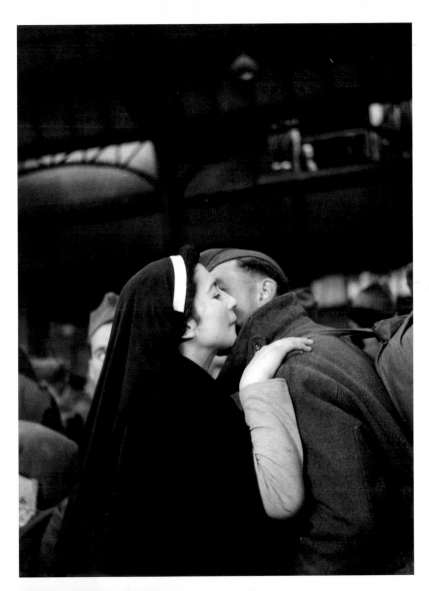

**V-E Day Celebration, Paris, 8 May 1945.** Ronis followed the route of the parade celebrating the Allied victory in Europe from its starting point at the Arc de Triomphe. He mingled with the enthusiastic crowd, photographing all the way, and was forced to stop at the Place de la Concorde and the Place de la Madeleine. From the fifth floor of a friend's fashion house he was able to get a measure of the crowd, and he finally followed it to where it reached its height, along the Grands Boulevards. It was there that he caught this evocative image, his camera following the movement of the crowded tank in the foreground.

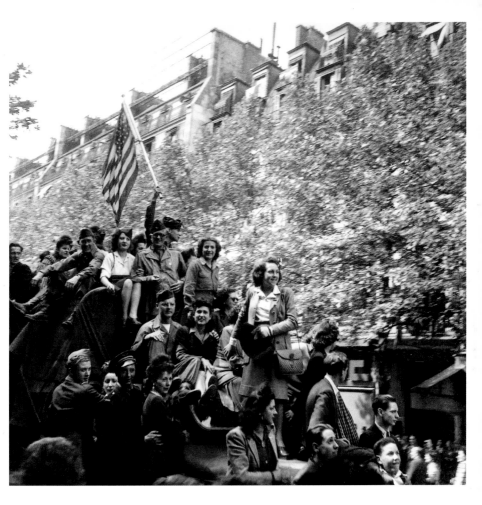

**A Break in Shooting, Paris, 1945.** In the winter of 1945, Ronis covered the shooting of the film *Le Roi des resquilleurs* (*The King of the Gatecrashers*) for a cinema magazine. 'So close to the end of the war, the sets were poorly heated. During a break in shooting, the girls who had just performed in the previous sequence persuaded the electricians to switch a few lights back on so that they could recharge their energy in the ensuing warmth.'

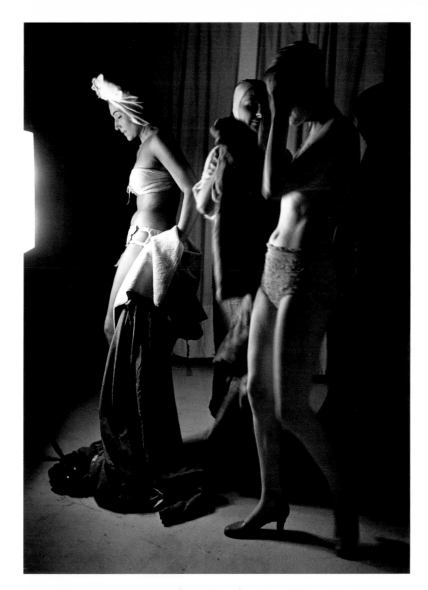

**Vincent Sleeping, Paris, 1946.** Ronis had married the painter Marie-Anne Lanciaux and had recently moved with her and her young son, Vincent, into a fourth-floor apartment on a wide boulevard. 'At eight one morning, Marie-Anne drew back the curtains and the oblique, winter sun highlighted the material of the rattan wall-hanging and caressed the face of the sleeping six-year-old. Seconds later, the light woke him.'

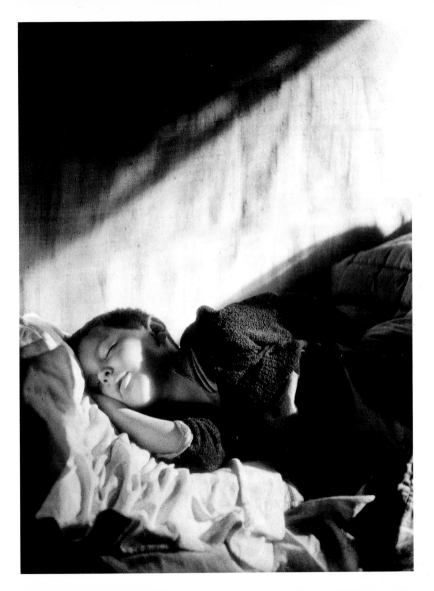

**Rue Rambuteau, Paris, 1946.** This street in the old market area of Les Halles dates from the mid-nineteenth century. 'All around Les Halles, generally on the pavements in front of certain cafés, you'd find stall-holders selling sandwiches, crêpes and chips in all seasons; chestnuts, mussels and oysters in winter.' Although the market itself has long since moved to the southern suburbs of Paris, the Rue Rambuteau – beyond the sections that touch on the new Forum des Halles and Pompidou Centre – still retains much of its original character.

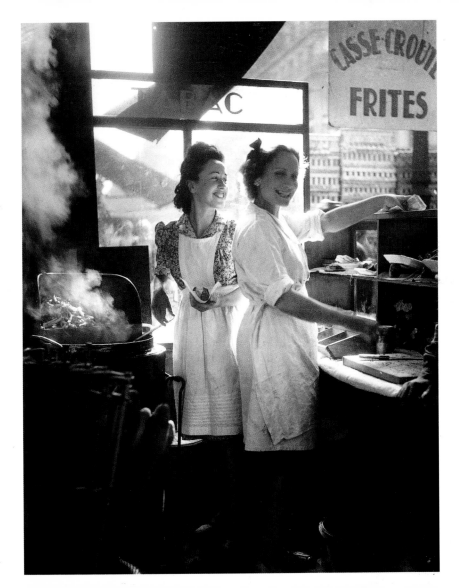

**Place Vendôme, Paris, 1947.** At midday, shortly after a rainstorm that had left the Place Vendôme awash with puddles, Ronis's attention was drawn to a pool of rainwater that reflected the historic Colonne Vendôme (erected in 1806 to honour Napoleon). A number of young women from the Place's many fashion houses passed by on their way to lunch. Ronis did not draw their attention, but pointed his camera at the ground. 'This is the best of the three shots I took.'

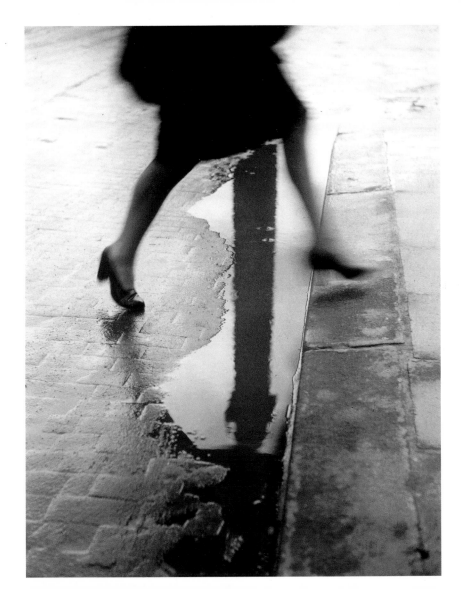

**Boules Player at Aubagne, 1947.** Ronis and his family took their holiday that year near this little town, 25 km east of Marseilles. 'The player was no doubt a professional who came from elsewhere for the championship, because when I returned later for an exhibition of my work at Aubagne, where this image was used as the poster, nobody was able to recognize him.'

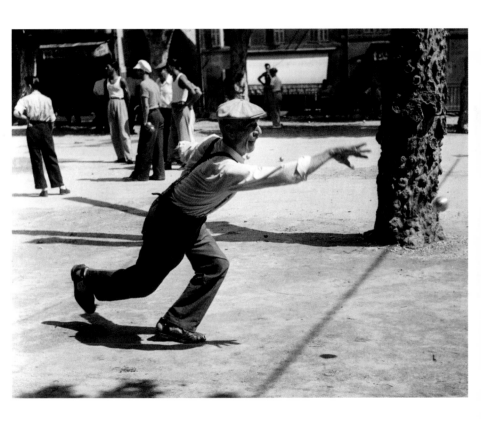

**André Lhote, Gordes, 1947.** Although best-known outside France these days as the man who taught painting to Henri Cartier-Bresson, Lhote was a distinguished theoretician of Cubism, art critic and teacher, as well as the author of a widely admired treatise on landscape. Here, as part of a commisioned report, Ronis captures Lhote on the terrace of his house in the Midi, where he gave lessons in summer to French and foreign students. The composition is at once a playful reference to Lhote's treatise on landscape and a stylistic evocation of Magritte with its hint of one world perceived through another.

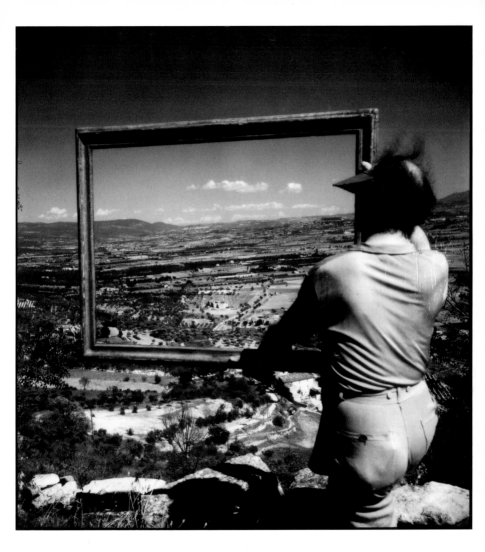

**Rue de Ménilmontant, Paris, 1947.** In the autumn of this year, Ronis began photographing the adjacent areas of Belleville and Ménilmontant, to which he is profoundly attached, and which would figure among his most famous work. Conscious of the speed at which the post-war Paris landscape was changing, Ronis spent a great deal of his spare time visiting the area and photographing a way of life that he felt was already under threat. 'Along the whole length of this steeply sloping street one could find little fruit and vegetable carts, one after the other.' The resulting book, *Belleville-Ménilmontant*, was first published in 1954 with a preface by the novelist Pierre Mac Orlan, who had declared himself an admirer of Ronis's 'poems of the street'. There were three reprints of the original version and, in 2000, a revised version was published with a new text by the crime novelist Didier Daeninckx.

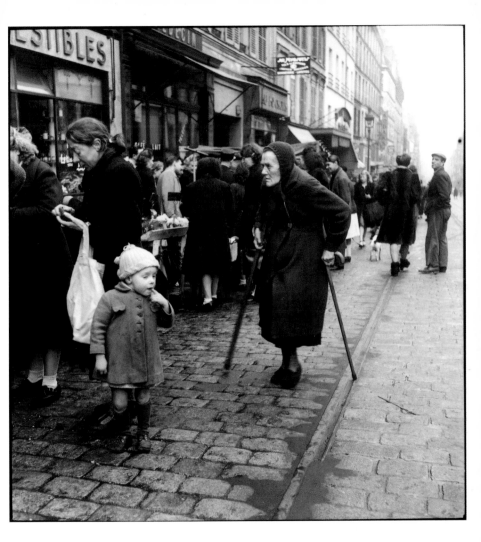

**Carrefour Sèvres Babylone, Paris, 1948.** This is a particularly bourgeois part of Paris, which Ronis often visited because it was close to the laboratory that printed his exhibition prints. On his way home on this occasion, he caught sight of the sun standing out against a veil of cloud. 'All I required was a human presence; after a few minutes of patience, I had it.'

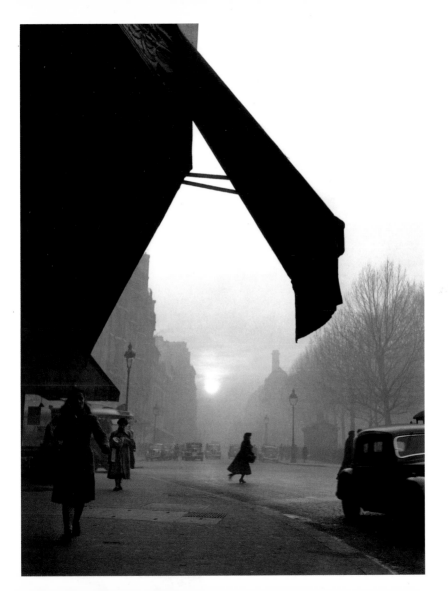

**Porte de Vanves, Paris, 1948.** Porte de Vanves is one of the southern gates of Paris and here, in the background, can be seen the remains of the ancient fortifications that were being demolished at the time to make way for the massive 35-km *Périphérique* (ring-road) that now circles the city. Vanves is also the site of one of the poorest flea-markets in Paris. 'Certainly', says Ronis, 'the most touching.'

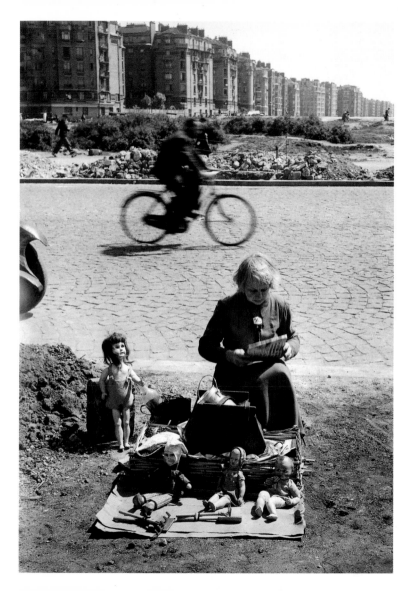

**Nu pauvre, Paris, 1949.** At the end of a reportage on the American Care founda-
tion, which distributed food parcels to needy families, Ronis met a young woman
who often posed for sculptors. 'I obtained permission from her parents for
her to become, on this occasion, a photographer's model. The location was their
sad lodgings in a very old house in the historic Marais district in the centre
of Paris.'

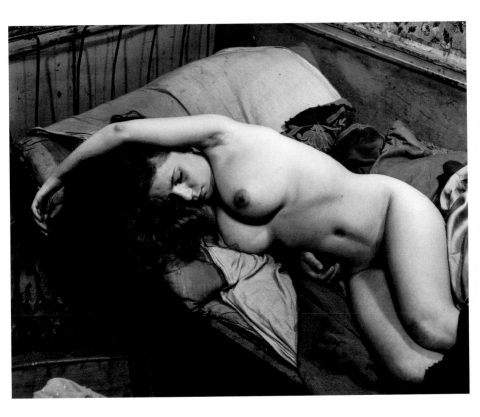

**Le Nu provençal, Gordes, 1949.** Ronis had visited Gordes when he photographed André Lhote, and it was the painter who convinced him and Marie-Anne to buy a derelict property in the area for their future holidays. There was much work to be done on the house and, in July 1949, Ronis was fixing the plasterwork in a loft when, in search of an implement, he passed by the bedroom and caught sight of his wife refreshing herself after a nap. 'I grabbed my camera and took four shots in under two minutes. The destiny of this image, published constantly across the world, still astonishes me.'

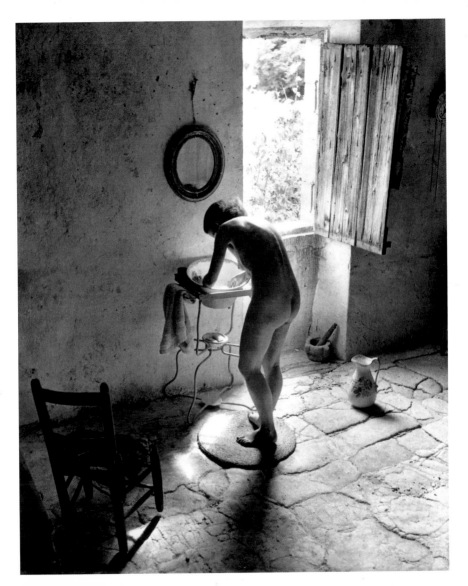

**Foundry, Renault Factory, Boulogne-Billancourt, 1950.** Ronis was one of ten photographers commissioned by the Renault car firm to contribute images to its fiftieth anniversary album. Of the 120 shots he took, this is the one he judged the best. While it was an honest image of factory life, its dramatic quality recalled the kind of harsh world depicted in Emile Zola's *Germinal*. Renault was aiming to promote itself as a modern company, and such a strong dose of social realism was deemed to have little publicity value. Ronis was disappointed but not surprised when it was not chosen for the company's album.

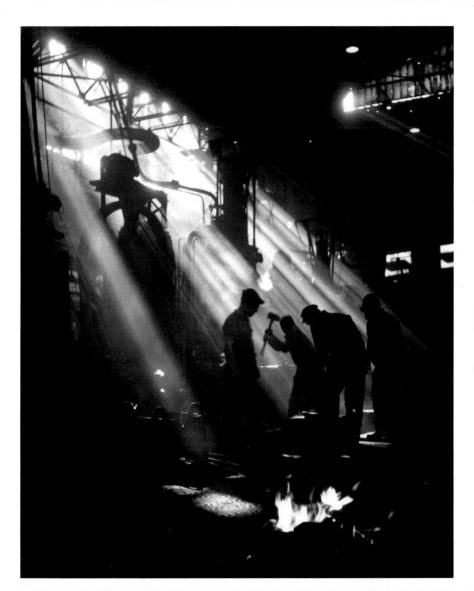

**Vincent, Aircraft Modeller, Gordes, 1952.** This is a very rare example of a staged photograph by Ronis. During a family holiday, Ronis was hoping to catch his son Vincent, now twelve years old, launching the model aeroplane he had made. But Vincent, nervous of the rocks beyond the Ronis garden, had no such plan. Finally, Ronis offered the boy a special present if he would agree to launch the model. Only two shots were taken. The first, an exterior shot, was unsatisfactory. This one, with Ronis deciding to frame the scene in the kitchen window of their holiday home, was a success – although Vincent's fears proved well-founded and the plane was badly damaged on landing.

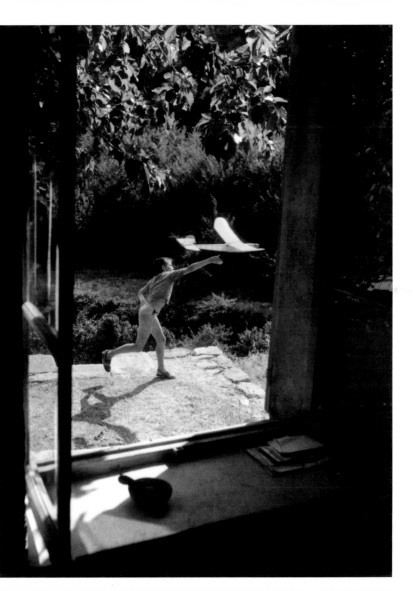

**Rue de Mogador, Paris, 1952.** Almost every year, with or without a commission, Ronis would photograph the Christmas shopping crowds in Paris. This image was taken before he finally switched in 1954 from his 6 x 6 cm Rolleiflex to the 35 mm format. The film stock he was using had a poor sensitivity to light and he had to hold the aperture wide open at a speed of 1/10th second, which inevitably led to some blurring. 'This is the most difficult of photographs to take,' he says, referring to the inevitable disorder of the scene. In such circumstances, he had to wait until a clear arrangement presented itself on the central plane, as it does here with the little girl and the attitudes of the bodies around her. He would employ this technique on other occasions, and it can be noted again in the 1979 photograph of the girl leaving the baker's shop in L'Isle-sur-la-Sorgue (page 89).

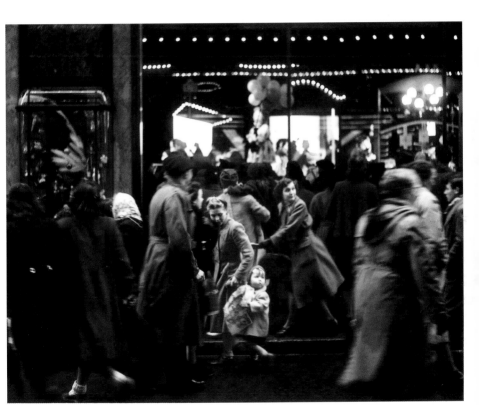

**Funfair, Paris, 1953.** Twice a year, at Easter and in October, a funfair arrived near to the Ronis apartment in the fifteenth arrondissement of Paris. One evening during the autumn fair, Ronis found himself surrounded by a group of young people demanding to be photographed. With poor light and no flash, he braced himself against a pillar, and took this shot at 1/5th second. 'Hence this strange mixture of sharpness and blur.'

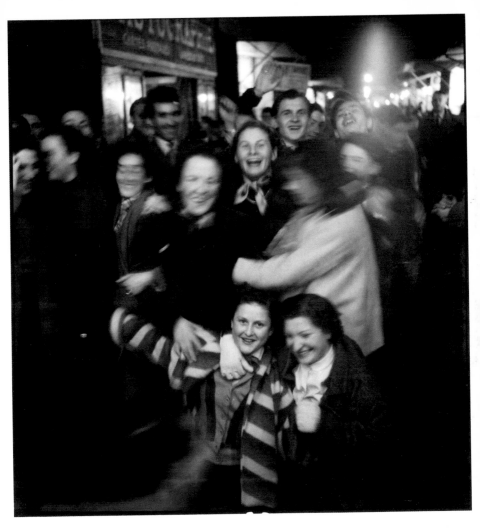

**Deena, Paris, 1955.** Deena was a young journalist and occasional model who offered to pose nude for Ronis. At the time, his apartment was not ideally suited for such work, so he visited her and found that her light-filled and only partly furnished flat was an excellent location. He took around forty photographs, of which this has become the most popular.

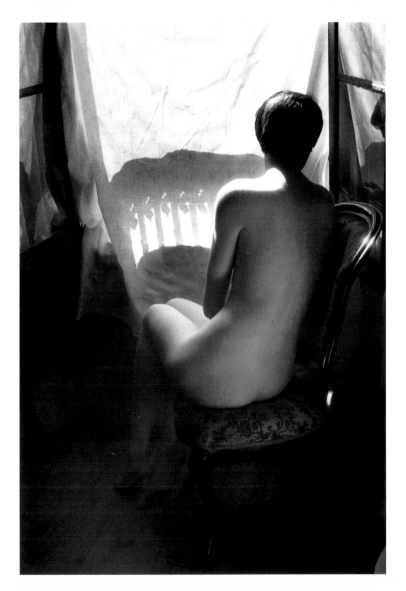

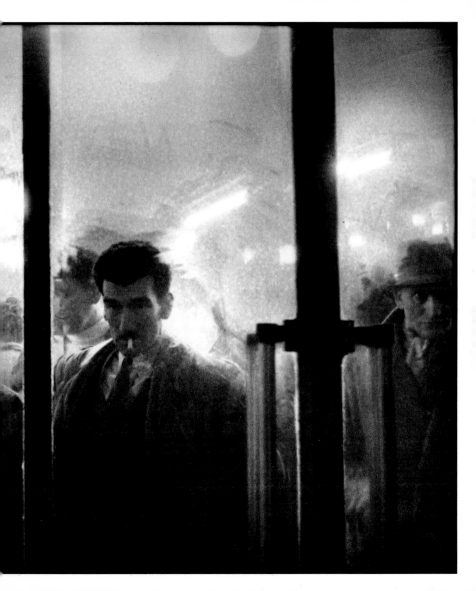

**(previous page) Rue Montmartre, Paris, January 1956.** It was a particularly windy and rainy day when, having just finished covering an election, Ronis hurried to the nearest Métro station. As he passed a café he noticed a group of customers staring out of the window, waiting for a break in the weather. He pulled his camera out from under his raincoat and took two shots, all the while holding on to his hat with his left hand.

**Le Vert-Galant, Paris, 1957.** One January morning, Ronis came across this young couple, wrapped up in their own universe at the westernmost point of the Île de la Cité on the Seine. Framing the couple in his viewfinder, he wished that a boat would pass to complete the ideal composition. 'Luckily, the cold didn't dampen their ardour, for it was a long time before a boat chanced to pass.'

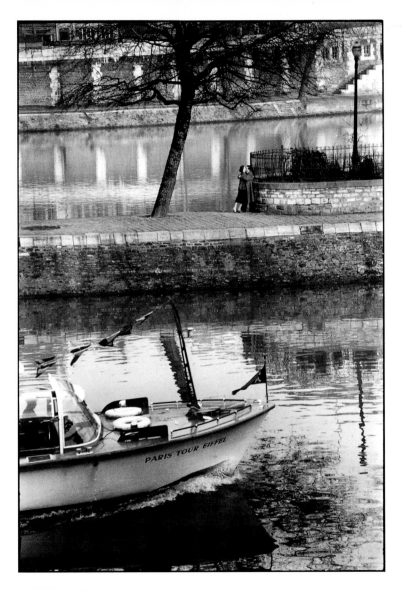

**The Lovers of the Bastille, Paris, 1957.** It is no longer possible to climb the Bastille Tower, which was erected to commemorate the Parisian dead of the 1830 Revolution, as it has been closed to the public for over twenty years. It once offered exceptional views of Paris, and Ronis had already climbed it many times when, on the way down from one such visit, he noticed this couple with the cityscape beyond them. Discreetly, he took one shot without their noticing.

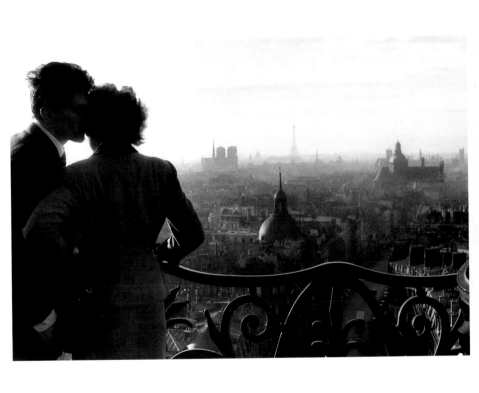

**Antwerp, 1957.** Chance has sometimes offered Ronis compositions as pleasing as any stylistic exercise, as was the case here when he found himself on a pleasure-boat forced to halt its progress at a lock. 'There is nothing much to look at when you are stuck between two high walls. That was also, no doubt, the opinion of the bargee's young daughter who looked out at us strangers as if we were animals in the zoo.'

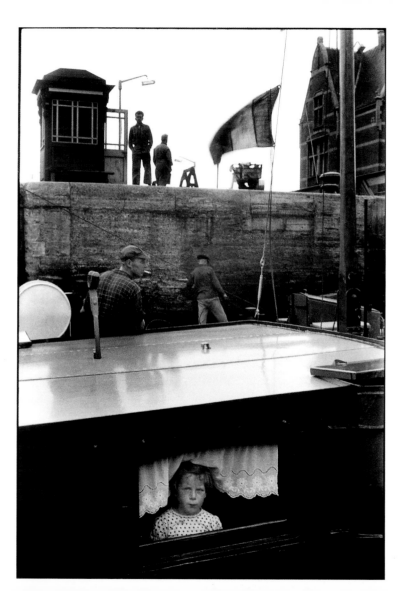

**Children on a Barge, Paris, 1959.** This is an example of the gifts that chance can bring. Ronis had passed an unprofitable day in late January, photographing along the banks of the Seine, with no real aim in view. The light was just beginning to fade, and he was about to head for home, when he heard the sound of children shouting. Running on to the Pont d'Arcole and leaning over its edge, he just managed to capture this unusual sight on the last frame of the roll he shot that day.

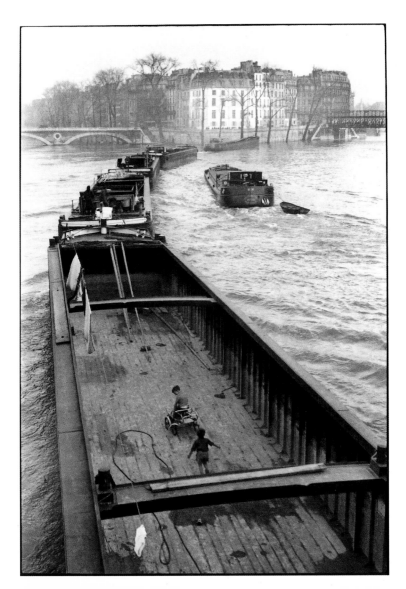

**Venice, 1959.** While Ronis and Marie-Anne were staying in a flat in Venice, one of their evening strolls took them into a working-class district away from the tourist areas. 'I was about to photograph a group of stone-workers relaxing in a bar after work when I heard female voices. I ran outside, followed by a little boy who was determined to be in the photo, and found two young women running along the little street on the left. I caught them before it was too late.'

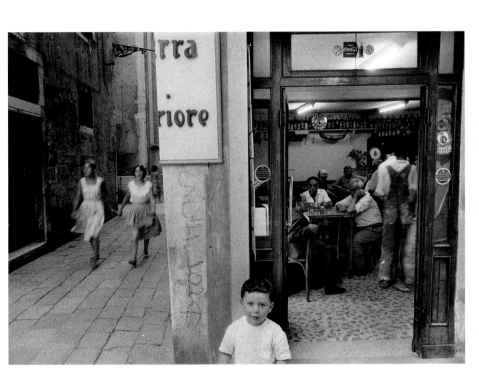

**Fondamente Nuove, Venice, 1959.** Again, on his Venice holiday, Ronis found himself in a part of the city that had very few tourists. He noticed a pleasing little walkway and waited patiently for someone to cross it. Nothing happened, and Ronis went away, but his frustration drove him to return just in time to catch this young girl silhouetted against the light with the shimmering water below her.

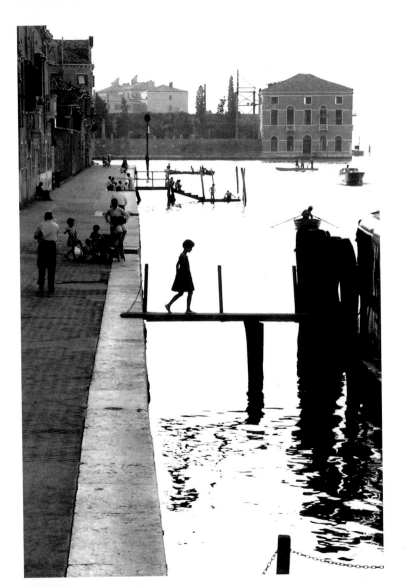

**Montmartre, Paris, 1960.** This is another rare example of a staged shot. While taking some portraits of Vincent, who needed them to get work as an actor, Ronis spotted a young couple embracing in a Montmartre street. He asked Vincent to sit on a bench and look sad 'as if just discovering his girlfriend's infidelity'.

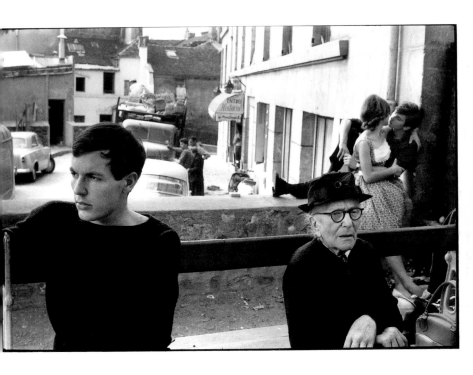

**The Farewell, Paris, 1963.** Ronis had just come down from his studio to his ground-floor apartment when he glanced through his window and spotted this couple. 'I took a couple of shots, unnoticed because of the curtain and the relative darkness of my room. From the boy's uniform, I assumed that I was witness to the end of a too-short naval leave.'

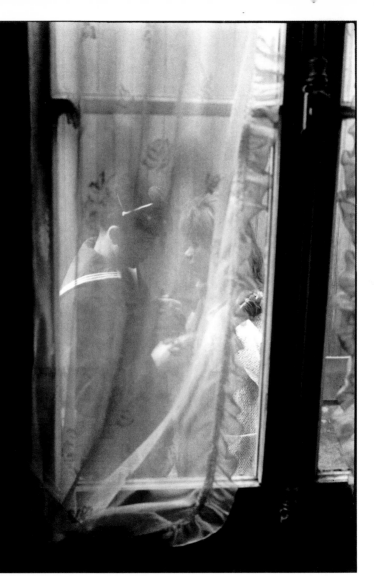

**Charles Bridge, Prague, 1967.** Ronis passed through Prague at the end of a job in Dresden, East Germany. Despite the fact that night was falling and it was beginning to rain, he wanted to photograph Charles Bridge. He was disappointed to find that it was being renovated, but nevertheless climbed a section of scaffolding and used his last shot of the day to catch this couple with their small child. He was so eager not to miss the moment that he slightly misadjusted the focus, but found the slight blur entirely in keeping with the mood of the image.

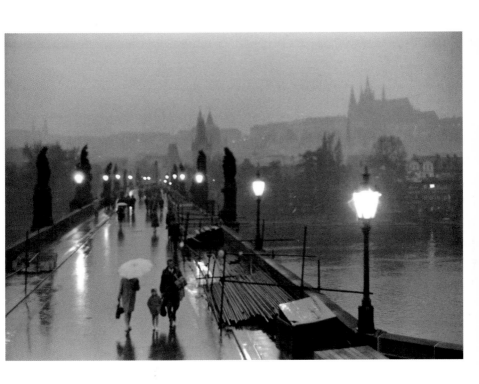

**Algiers, July 1969.** Ronis was one of five photographers commissioned to cover the first Panafrican Festival when this shot was taken. He was spending a moment of his free time observing the crowd in a street that reached from the sea to the heights of the Casbah, and climbed on to a bench to improve his viewpoint. The young girl in the centre paused for a moment, intrigued by the photographer, but it is the chance placing of the two white-shirted men, at bottom left and bottom right of the frame, that balances her and gives the image its compositional strength. Even though we may not notice those figures at first, the image would suffer badly if they were cropped out or not in place. Given that this crowd was in constant movement, nothing better illustrates the way in which timing, and Ronis's musical sensitivity to it, plays such a significant role in photographic composition.

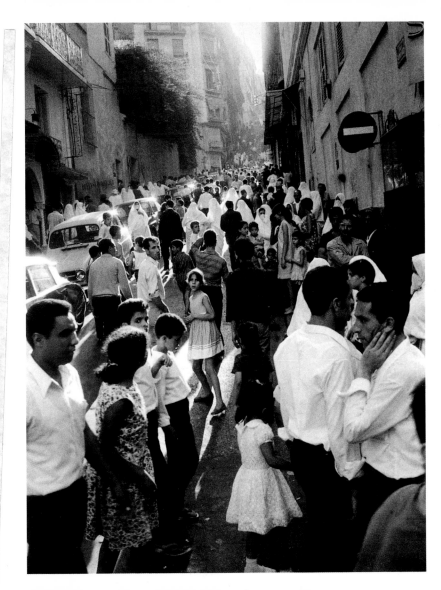

**Nude in Striped Polo-neck, Paris, 1970.** As a general rule, Ronis does not work with professional models, preferring to collaborate with friends or with non-professionals who have chosen to approach him. This is one of a series of nudes that he shot with a professional model with whom he had struck up a rapport when they worked together on an advertising shoot. Although it was an interior shot, the cracked background gives the impression that it has been taken outside, on a sunny day beside the sea.

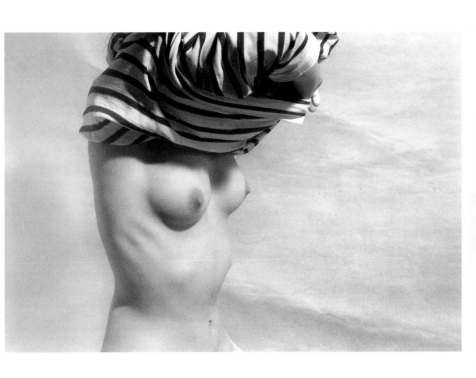

**The Charterhouse, Villeneuve-lès-Avignon, 1979.** Once the most important Charterhouse in France ('If Avignon was the town of popes, then Villeneuve was the town of cardinals,' says Ronis), this has now become a cultural centre. The photograph was taken in July, on the eve of the annual Avignon Festival. Ronis was struck by the way in which a series of open doors led, like a corridor, to the stage where a solitary dancer had stayed behind after rehearsal to master a difficult dance movement. If he had used the standard 50 mm lens of his camera for this shot, Ronis would have had to go much closer and lose the corridor effect; he opted instead for a 135 mm telephoto lens.

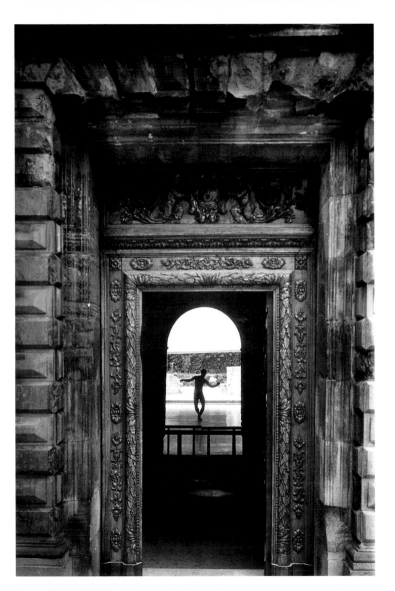

**L'Isle-sur-la-Sorgue, 1979.** This small town in the Midi has one of the most picturesque Sunday markets in Provence. Ronis particularly liked this baker's shop with its painted wooden sign dating from the early twentieth century. The photograph was taken at a moment that coincided with the thinning of the dense crowd and the exit from the shop of the young woman in the white dress.

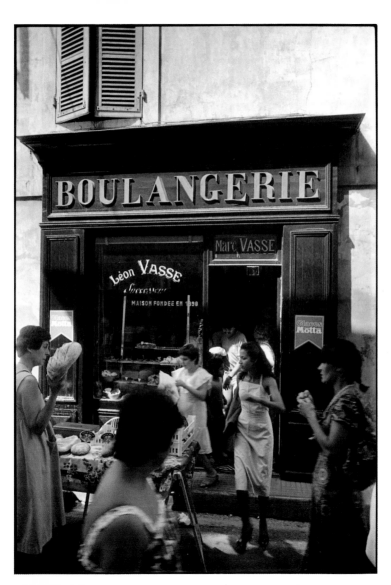

**Le Café de France, L'Isle-sur-la-Sorgue, 1979.** In the same location as the previous photograph, and again during the busy Sunday market, Ronis took this shot of the café opposite the church in the centre of the town that is popular with locals and tourists alike. The focus is clearly on the woman leaving the café, but the effects of sunlight have enabled Ronis to achieve a subtle counter-balance with the brightly lit woman at the bottom left of the frame and the white-shirted adolescent at bottom right. The composition would hold, even if they were cropped out, as there is an inner symmetry with the young boy and the woman on either side of the central figure, seated with their backs towards each other.

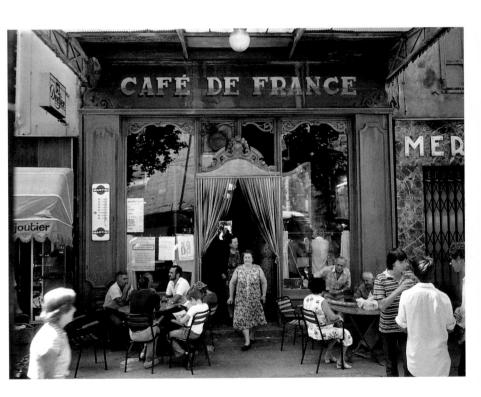

**Návplion, 1980.** Ronis visited Greece for an exhibition of his work in Athens. On the advice of the show's curator, John Demos, he passed by the port of Návplion in the Argolic Gulf. From one of the town's little streets, Ronis spotted the turret of the impressive citadel that dominates Návplion. By chance, a woman then walked on to her balcony to hang out her washing.

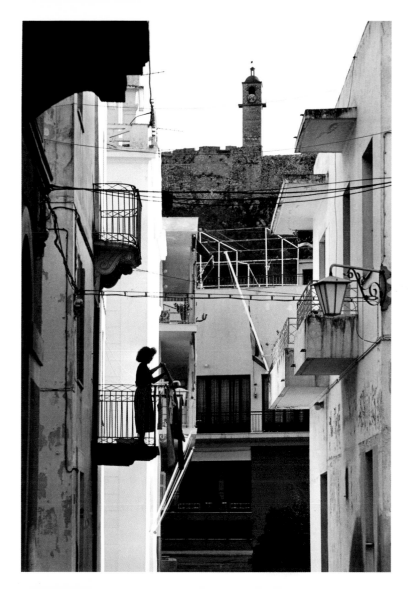

**La rue du Télégraphe, Paris, 1980.** Ronis returned to the twin areas of Belleville and Ménilmontant for this shot. This street is the highest in Paris, two or three metres higher than Montmartre. On a piece of waste ground popular with boules players, a game has just ended. Ronis found that the moment when the players packed away their boules had a balletic quality.

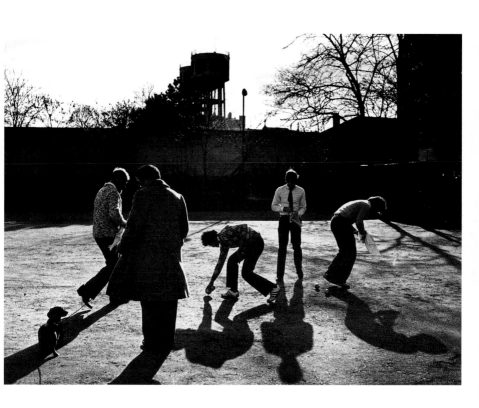

**Rue de la Monnaie, Paris, 1981.** The old market of Les Halles had given way to shops and department stores in the new Forum des Halles, still under construction. In front of a window stocked with mannequins, Ronis spotted this worker with his mechanical digger.

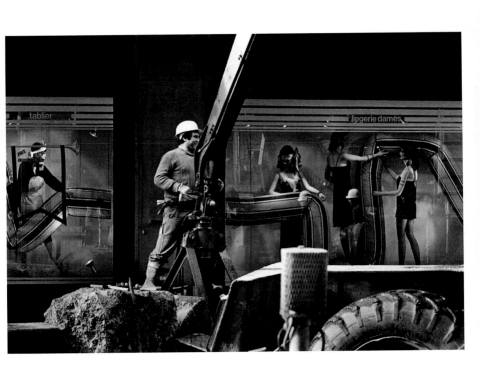

**Villa Medici, Rome, 1981.** Ronis spent a week at the French School in Rome at the invitation of Bernard Richebé, the first photographer admitted as a resident artist at the Villa Medici. Admiring the form of a young sculptor there, Ronis persuaded her to pose for him. His own foot appears in the frame, as this was the only way he could balance himself for the angle he wanted.

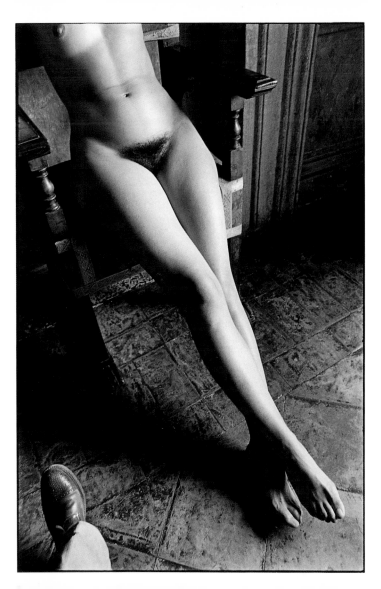

**Le Crotoy, 1986.** If staged photographs are rare for Ronis, those without human figures are rarer still. Here, he had just finished lunch with friends at a beach on the Somme Estuary. As he got up to leave, he was struck by the accidental composition he saw with its three planes in one image.

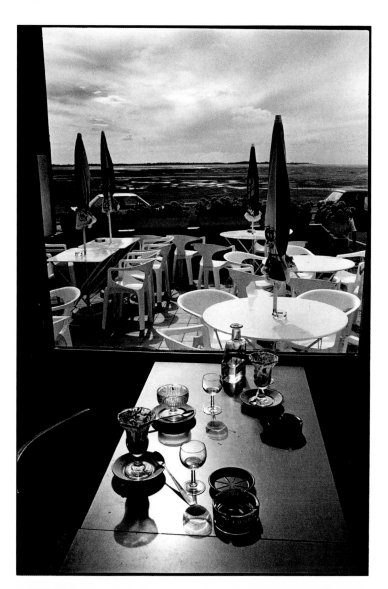

**Pushkin Palace, Leningrad, 1986.** 'Museum visits put children under often unbearable strain,' Ronis notes of this scene. 'I had watched that little boy becoming more and more impatient and this is the moment when he refused to follow his mother on another step of that painful trip.'

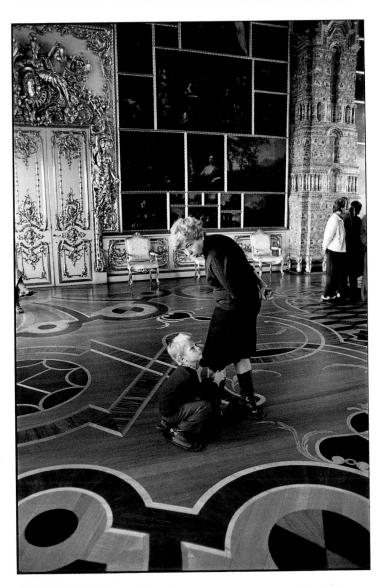

**Joinville-le-Pont, 1989.** 'This scene is a little surrealist. I imagine that the little girl was given the pretty little car for her birthday. She wanted to give a ride to each of the dogs in turn. Her father was standing by as a security measure.'

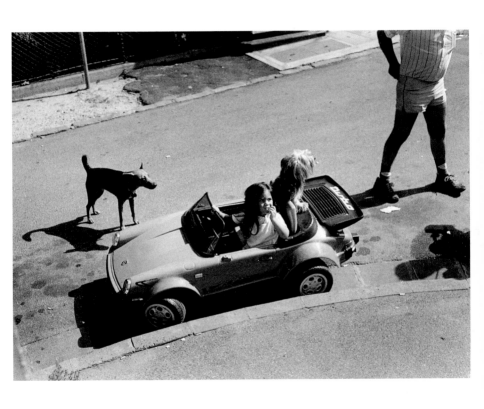

**Nude, Paris, 1990.** Ronis still finds nude studies challenging: 'It is so easy to border on the vulgar or the ridiculous.' This is now the main form of photography he practises, since he no longer has the physical agility to chase after images. 'With the nudes, I don't have to run; they come to me, or I go to them.' His Paris apartment, where this shot was taken, has a north light that would be the envy of many painters.

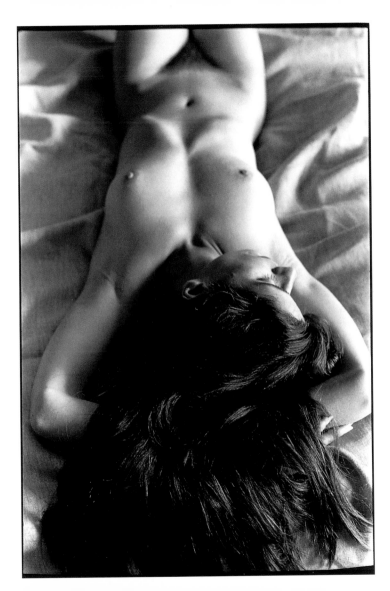

**Île de la Réunion, 1990.** Ronis visited this French-governed island in the Indian Ocean for an exhibition that featured his work. He was returning from photographing dockers in the ports of Saint Paul and Saint Gilles when he became fascinated by this family doing their washing in a local creek.

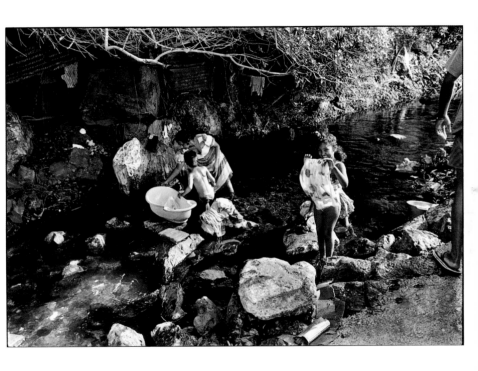

**Boulevard Haussmann, Paris, 1990.** Between 1987 and 1999, Ronis made a series of images of this blind musician, Stéphane C., entertaining the crowds during Christmas week. This twilit image is Ronis's favourite. But Stéphane C. will no longer be found in his customary spot at Christmas; he died in January 2001.

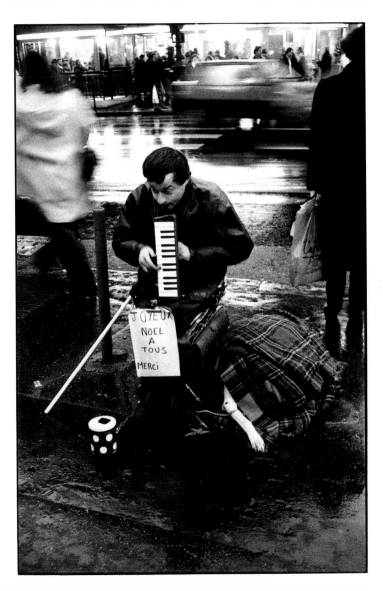

**The Card Game, Joinville-le-Pont, 1991.** In the last years of her life, Marie-Anne was cared for in a nursing home in Nogent-sur-Marne, just outside Paris. Every weekend, Ronis would visit her and they would take walks along the banks of the River Marne. This photograph was taken, shortly before Marie-Anne's death, in one of the cafés they often visited during their walks. It was a fine February afternoon, and the sunlight on the group of card-players attracted Ronis, who took out his camera and waited until the central player lifted his card to slap it down on the table in triumph. 'I had often photographed the customers there, but never in such an astonishing light.'

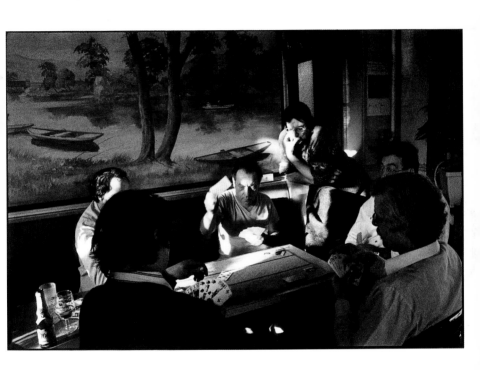

**Saint-Benoît-du-Sault, 1991.** The mayor of this town in central France was a great admirer of photography, and particularly of Ronis's work. To promote the town, he commissioned a series of photographs by Ronis, to be published in a book with a text by the mayor himself. Many aspects of the town's daily and seasonal life were covered. Here, two young actresses from a travelling theatre company are seen in their makeshift dressing-room, moments before performing in an open-air show.

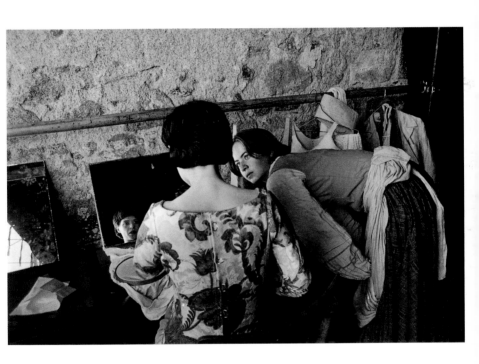

**Saint-Benoît-du-Sault, 1991.** At the town's cattle market, Ronis climbed on to a cart to keep out of the way. Looking down, he was struck by the sight of a breeder tying an animal to a crossbar. What interested him most in this composition was the contrast between the curved backs of man and animal, and the tense, straight lines of the bars. It also illustrates his habit of finding ways to place himself at a higher point than that of his subject. This willingness to alter his perspective on a scene led to some of his most striking compositions.

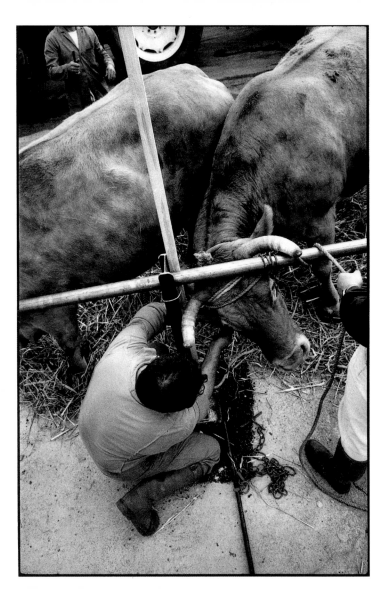

**Valmorel, 1992.** A combination of minimum staging and chance makes this image a cousin to the ones taken in Antwerp and Le Crotoy (pages 69 and 101) — each with its three planes of interest. Ronis merely placed the sun-glasses and note-book on the table to liven up the foreground. Soon afterwards, the waiter arrived to serve the mother and child, and a passing skier completed the composition.

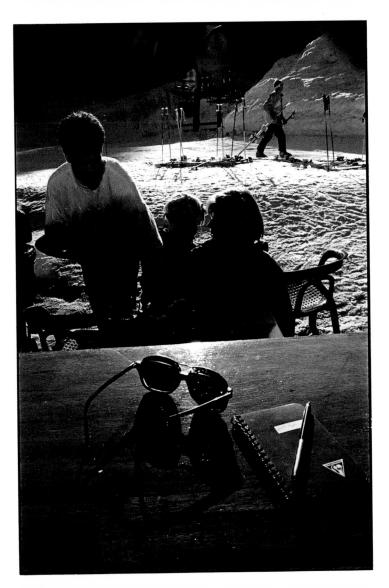

**Château-Lafite, 1993.** The grapes for this famous wine come from the region between Bordeaux and the Atlantic coast. To capture this scene of the October grape harvest on a difficult day that mixed showers with sunny intervals, Ronis climbed on to the tractor that was to transport the grapes to the wine cellars. This placed him on a level with the carts into which the grape-harvesters emptied their baskets.

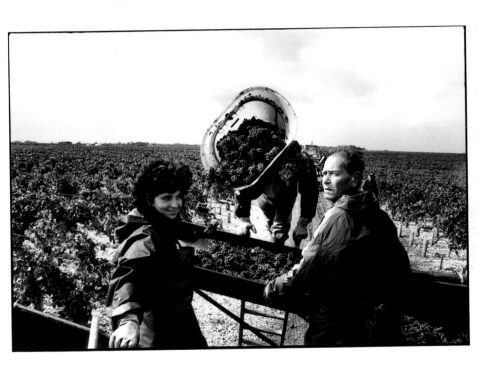

**Fête de la Musique, Place des Vosges, Paris, 1998.** In 1981 the French Minister of Culture Jack Lang designated 21 June as an annual 'day of music' throughout France. Here a group of musicians plays in the arcades of the Place des Vosges, which dates from the seventeenth century.

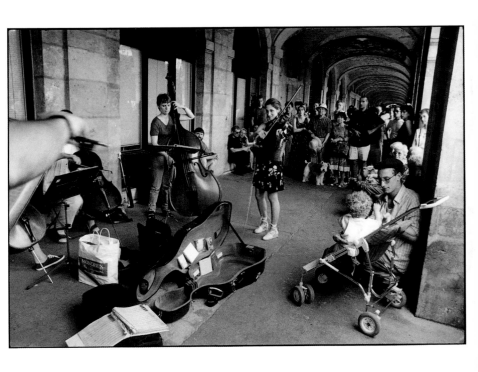

**Nude, Djerba, 1998.** Ronis was invited to the island of Djerba, off Tunisia, as a participant in an exhibition and to give an illustrated lecture. This photograph was posed by a fellow photographer on the terrace of an apartment by the sea. The faces of Ronis's nude models are rarely clearly visible, often because the models themselves do not wish to be recognized. Sometimes this is achieved simply by not including the head in the shot. But the oblique angle, as in this image, points to the quality of discretion and the refusal to intrude that characterizes so much of Ronis's work. Uninterested in straightforward portraits, Ronis prefers to capture people on their own terms and in their own worlds. As a result, even in his crowd shots, Ronis frequently touches on the uneasy theme of human solitude. It is this quality, above all, that gives his work an edge of truth.

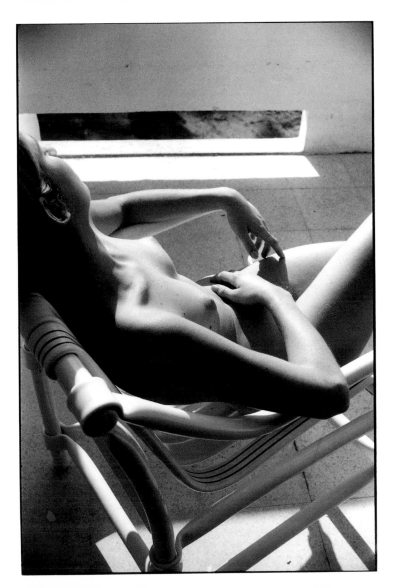

**1910** Born in Paris to Jewish immigrants from Russia and Lithuania.

**1926** Acquires his first camera and spends his holiday taking photographs. Also starts to photograph Paris.

**1932** Begins work at his father's photographic studio.

**1936** Death of his father and collapse of the family business. Decides to earn his living as a freelance photographer. First pictures are published in *Regards*.

**1937** Produces 'Neige dans les Vosges' exhibition at the Gare de l'Est, Paris. Meets David Szymin ('Chim') and Robert Capa. First assignment for *Plaisir de France*.

**1938–1939** Reports on the strike at Citroën. Travels in Greece, Yugoslavia and Albania.

**1941–1944** Stage manager for travelling theatre company in Non-Occupied Zone in south of France. Meets Marie-Anne Lanciaux, a jewellery painter, whom he marries two years later. Returns to Paris in October 1944.

**1945–1950** Works for illustrated press: *Point de Vue*, *L'Ecran Français*, *Regards*, *L'Illustration*, *Le Monde Illustré*. Member of the Groupe des XV. Joins Rapho Agency. From 1947, works on Belleville-Ménilmontant project. Awarded the Prix Kodak in 1947.

**1951** Publishes *Photo reportage et chasse aux images*.

**1953** Participates in 'Five French Photographers' at the Museum of Modern Art, New York, with Cartier-Bresson, Brassaï, Doisneau et Izis.

**1954** Publishes *Belleville-Ménilmontant*, with text by Pierre Mac Orlan.

**1957** Awarded Gold Medal at Venice Biennale. Begins teaching part-time.

**1965** Participates in the exhibition 'Six Photographers and Paris', Musée des Arts Décoratifs, Paris, with Doisneau, Frasnay, Lattès, Pic and Janine Niepce.

**1972** Leaves Paris for Gordes, then L'Isle-sur-la-Sorgue. Teaches at the

School of Fine Arts, Avignon; at the Faculty of Letters in Aix-en-Provence; and the Saint Charles Science Faculty, Marseilles.

**1975** Made Honorary President of National Association of Photographers-Reporters-Illustrators.

**1979** Awarded the Grand Prix des Arts et Lettres for Photography by the Minister for Culture.

**1980** Publishes *Sur le fil du hasard*.

**1981** *Sur le fil du hasard* wins the Prix Nadar.

**1982** Full-length film *Un voyage de Rose,* with Willy Ronis and Guy Le Querrec, made and directed by Patrick Barbéris.

**1983** *Willy Ronis* is published. Donates his photographic work to the French state. Returns to Paris and continues to work with Rapho

**1984** *Belleville-Ménilmontant* is republished.

**1985** Publishes *Mon Paris*. Official retrospective held at the Palais de Tokyo, Paris. Named Commandeur de l'Ordre des Arts et des Lettres.

**1986–1989** Exhibitions in New York, Moscow and Bologna. Named Chevalier de la Légion d'Honneur.

**1995** Exhibitions in Washington, DC, New York and Tokyo. Major retrospective at the Museum of Modern Art, Oxford.

**1996** Major retrospective '70 ans de déclics', Pavillon des Arts, Paris.

**1999** Publishes *Marie-Anne, Vincent et moi*.

**2000** Exhibitions at the Musée de la Photographie (Charleroi), Kiev, Cologne, Kyoto. Publishes *Mémoire textile*. 'Willy Ronis, Photographies' exhibition held at the FNAC Etoile, Paris, to celebrate his ninetieth birthday.

**2001** Publishes *Derrière l'objectif*. Named Commandeur de l'Ordre National du Mérite.

Photography is the visual medium of the modern world. As a means of recording, and as an art form in its own right, it pervades our lives and shapes our perceptions.

**55** is a new series of beautifully produced, pocket-sized books that acknowledge and celebrate all styles and all aspects of photography

Just as Penguin books found a new market for fiction in the 1930s, so, at the start of a new century, Phaidon **55**s, accessible to everyone, will reach a new, visually aware contemporary audience. Each volume of 128 pages focuses on the life's work of an individual master and contains an informative introduction and 55 key works accompanied by extended captions.

As part of an ongoing program, each **55** offers a story of modern life.

**Willy Ronis** (b. 1910) is one of the greatest representatives of French photography of the 1950s. His belief that 'the beautiful picture is a geometry modulated by the heart' is revealed in his sensitive and affecting images of human relationships and everyday life. His most important work is considered to be his survey of a working-class area of Paris between 1947 and 1951, published as *Belleville-Ménilmontant* (1954).

**Paul Ryan** has written on the arts for numerous publications and has lectured at the Tate and Hayward galleries in London. In 1996, he was created Chevalier de l'Ordre des Arts et des Lettres by the French government.

Phaidon Press Limited
Regent's Wharf
All Saints Street
London N1 9PA

Phaidon Press Inc.
180 Varick Street
New York NY 10014

www.phaidon.com

First published 2002
©2002 Phaidon Press Limited

ISBN 0 7148 4167 6

Designed by Julia Hasting
Printed in Hong Kong

To J.B., friend and pathfinder into the forest, with gratitude.